WHERE'S KARL?

POTTER STYLE
NEW YORK

WHERE'S KARL?

A FASHION-FORWARD PARODY

Stacey Caldwell and Ajiri A. Aki

Illustrated by Michelle Baron

Copyright © 2015
by Stacey Caldwell and Ajiri A. Aki

Published in the United States by Potter Style,
an imprint of the Crown Publishing Group,
a division of Penguin Random House LLC, New York.
www.crownpublishing.com
www.potterstyle.com

POTTER STYLE and colophon are registered trademarks of Penguin Random House LLC.

Library of Congress Cataloging-in-Publication Data
Caldwell, Stacey.
Where's Karl? : a fashion-forward parody / Stacey Caldwell, Ajiri A. Aki ; illustrated by Michelle Baron.
1. Lagerfeld, Karl—Parodies, imitations, etc. 2. Fashion—Humor. I. Aki, Ajiri A. II. Title.
TT505.L34C35 2015
818'.602—dc23
2014047668

ISBN 978-0-553-44792-7
eBook ISBN 978-0-553-44793-4

Printed in China

Book design by Danielle Deschenes
Illustrations by Michelle Baron
Cover design by Michael Nagin

1 3 5 7 9 10 8 6 4 2

First Edition

For Lilly and Steve
—SC

For my mother
—AAA

INTRODUCTION

Bonjour! Florence de la Sabine here, but you can call me Fleur. Welcome to the launch of what will surely become your daily dose of inspiration, FollowingFleur.com—the blog where you can join me as I travel around the world and document my #ootd, best Instagram dessert attempts, adventures, observations, and rather unhealthy but studied fascination with the kaiser of fashion, Karl Lagerfeld. But let's backtrack—first you need a few important details about *moi*.

My French mother, a model in the seventies and eighties, and my American father, a writer and artist, met each other by way of the legendary editor, writer, painter, socialite, and philanthropist Fleur Fenton Cowles. My parents always said if they settled down after the wild seventies (and it was a *big* if!), they would name their firstborn after the creative luminary who so fabulously brought their worlds together. Clearly you can see how that worked out.

Growing up in Paris as a child and in Switzerland during my boarding school years, I was fascinated by my namesake—even going so far as to accessorize my school uniform with ridiculous costume jewelry and crazy thick, oversized black glasses. I got a few demerits, but you have to fight for your right to accessorize, *non?* It was destiny that I would follow in Madame Cowles's footsteps and create something like *Flair* magazine—the 1950s version of *Visionaire, V, Vanity Fair,* and *Vogue* all rolled into one.

Having close friends and mentors in the fashion and film worlds is wonderful, but I needed some street cred in the industry before I jumped in. I honed my skills and sharpened my eye during internships and freelance stints at Proenza Schouler, *Harper's Bazaar, W* magazine, and the Cut—ordered coffee, trafficked samples, and fact-checked. I paid my dues, to say the least! (Didn't we all?) But these

were all great opportunities. What could be better than helping Jack and Lazaro find inspiration for their new collection or assisting Edward Enninful on a shoot in Marrakech? Nevertheless, in the back of my mind, I always asked myself, "Why work for someone else?" Experience matters, but the beauty—and perhaps the beast—of the twenty-first century is that armed with a solid idea, persistence, prowess, and a WordPress account, you can do a lot and reach millions of people. Let's be honest, though; youth doesn't hurt either. My generation gave rise to social media and the many digital platforms that are turning us all into entrepreneurs. *Et voilà:* the birth of Following Fleur.

As a child I begged *maman* to share the tales of her international jet-setting and modeling career. Just like Karl, who believes "there is nothing worse than bringing up the good old days," my mother never wanted to rehash what she thought were ancient and useless stories. Ironically, though, she was generous with her glamorous tales of modeling for Chloe and Chanel, which, somewhere along the way, led to my obsession with Karl Lagerfeld. He is truly the definition of a savant and a modern-day Renaissance man. How on earth does he manage to design for three brands, direct commercials, collaborate on special projects, work as a photographer and an illustrator, and read a zillion books? The man has endless amounts of energy, and a proliferation of ideas continues to pour out of him. I guess you can have it all—which brings me to my *raison d'être.*

I need to find Karl because he is my muse. I believe he is the key to taking my blog to the next level. Okay, fine, I would be lying if I didn't admit there is a bit of a sentimental factor. The wild nights I mentioned earlier finally caught up with *maman,* and I know Karl can fill in where her stories left off. Of course I want to feel that connection to her past, but I also need to understand *l'esprit du temps* of another era in fashion. The spirit of the past also lives within and informs the spirit of the present, and Karl, as a savant, *par excellence,* is just the person to help me bring that all together. As my wise father always says, "What's past isn't merely prologue; it's the earlier part of now." I think I finally understand: Karl is someone who can tell me not just of the good old days, but also about what makes style and fashion so eternal. Okay, that was all probably too deep, but I did warn you my father is a creative.

As I was saying, knowledge from Karl will make Following Fleur different from the multitude of fashion blogs out there all featuring the same information in the same fashion. (Pun intended.) In order to create something truly inspired by *Flair* magazine—where the focus is on legends, muses, good writers, and designers—delivered with innovative design in a modern context, I need to speak with that "Karl-o-pedia."

Now, the only problem in my master plan is that Monsieur Lagerfeld can be difficult to locate, as he is always on the move. Surely once we sit down for a *tête-à-tête,* he will also agree to add a columnist feather to his cap and text—one of his preferred methods of communication—in a weekly post of his *bons mots,* similar to the late Diana Vreeland's *Harper's Bazaar* "Why Don't You . . . ?" Yes, this will make blogger history of epic proportions. But first I need to know—and I need your help—where's Karl?

The fashion industry is chock-full of mostly undiagnosed lunatics and megalomaniacs with highly covetable outfits who speak in superlatives and use far too many exclamation points. That's why it's the absolute best industry ever!!!!! You can follow *moi* and catch a glimpse of Anna, André, Grace, Hamish, Carine, Blake, Kate, Karlie, Naomi, Kristen, Keira—who needs a last name these days?—and, if a certain overpriced fortune-teller on my Eat-Pray-Shop tour through Bali was right: Karl. #followingfleur #fleurfollowers #worldtour #confessionsofakarloholic #whereskarl

In case you have been living under a rock for the last several decades, let's go over Karl's signature elements of style that might help you spot him:

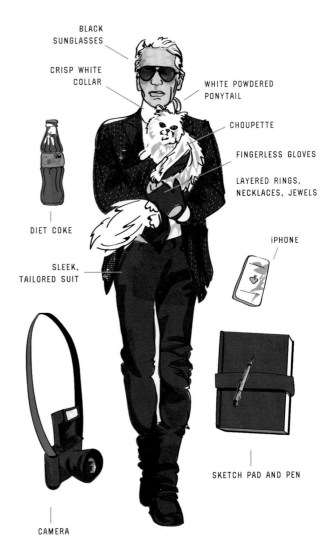

BLACK SUNGLASSES

CRISP WHITE COLLAR

WHITE POWDERED PONYTAIL

CHOUPETTE

FINGERLESS GLOVES

LAYERED RINGS, NECKLACES, JEWELS

iPHONE

DIET COKE

SLEEK, TAILORED SUIT

SKETCH PAD AND PEN

CAMERA

There you have it: all you need to follow me around the world and help me find Karl. Oh, and should you end up on my flight at any point, *s'il vous plaît,* don't disturb me if my eye mask is on. See you soon!

Bisous XX

CONTENTS

I thought you might want to review our itinerary ahead of time. According to Karl's bodyguard, Sébastien Jondeau, he is booked solid with appearances and events for the next twelve months! We'll begin our search in Milan at the party of the year, the Fendi Baguette *fête,* and end in London at the Royal Ascot. I'm thrilled to have help along the way, so get to booking those tickets. We have fifteen cities to cover—pack that Louis lightly!

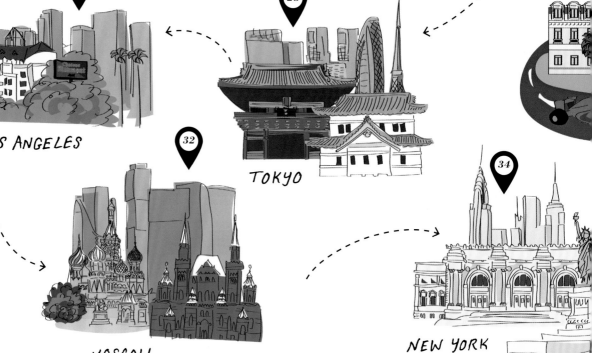

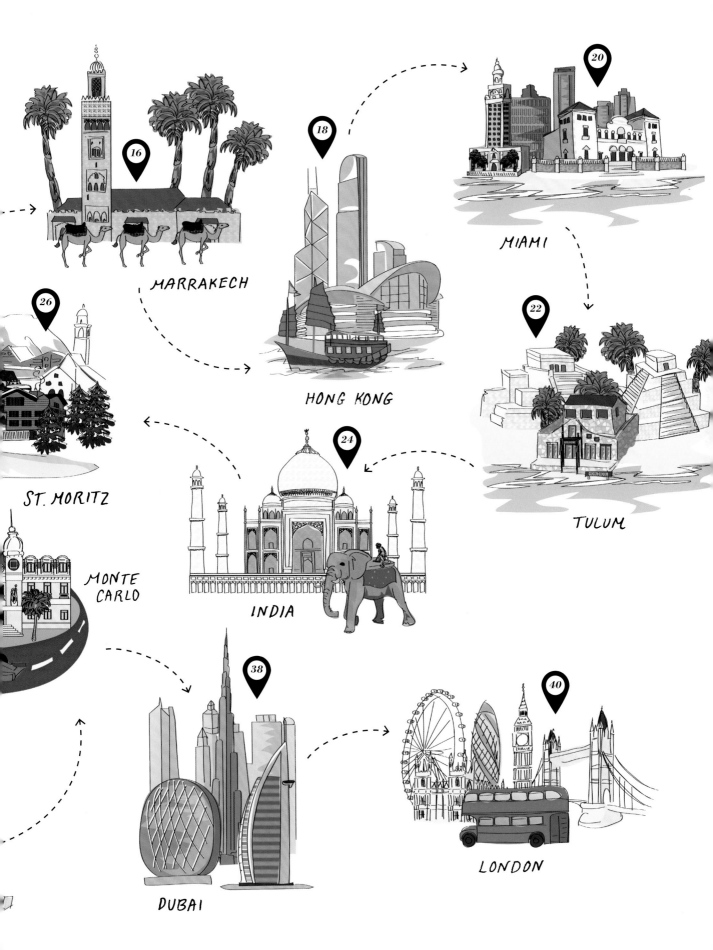

CHARACTER LEGEND

As we begin our search for Karl, I must also point out a few of my favorite icons, friends, and characters—some of whom are part of Karl's entourage, all of whom we hope to meet along the way. Keep your eyes open, because this army will lead us to Monsieur Lagerfeld. We all know the fashion industry travels as a pack, so I'm certain they will be along for the ride from LA to Tokyo and back! And of course keep your eyes peeled for other celebs and style crushes, too. We're sure to encounter many *interessant* personalities on this journey...

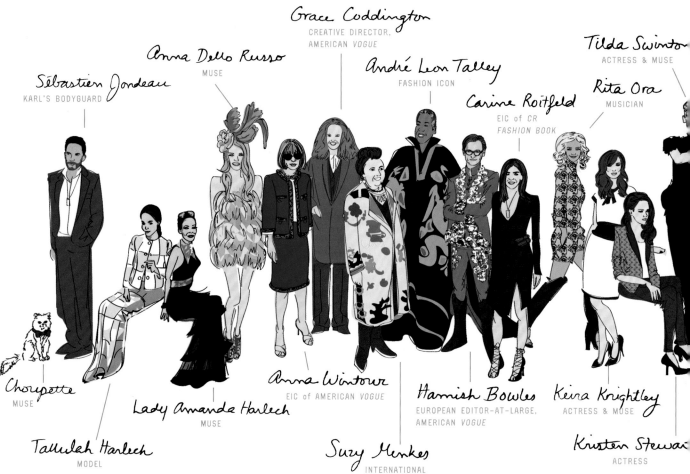

Grace Coddington
CREATIVE DIRECTOR,
AMERICAN *VOGUE*

Anna Dello Russo
MUSE

André Leon Talley
FASHION ICON

Tilda Swinton
ACTRESS & MUSE

Sébastien Jondeau
KARL'S BODYGUARD

Carine Roitfeld
EIC of CR
FASHION BOOK

Rita Ora
MUSICIAN

Choupette
MUSE

Anna Wintour
EIC of AMERICAN *VOGUE*

Hamish Bowles
EUROPEAN EDITOR-AT-LARGE,
AMERICAN *VOGUE*

Keira Knightley
ACTRESS & MUSE

Lady Amanda Harlech
MUSE

Tallulah Harlech
MODEL

Suzy Menkes
INTERNATIONAL
EDITOR of *VOGUE*

Kristen Stewart
ACTRESS

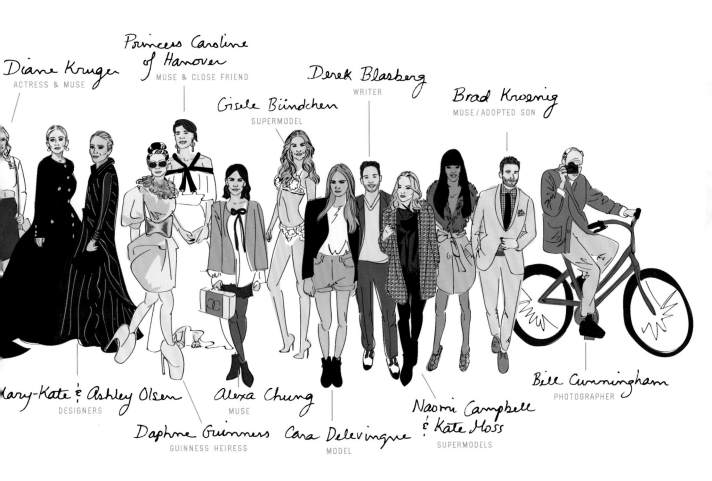

Diane Kruger
ACTRESS & MUSE

Princess Caroline
of Hanover
MUSE & CLOSE FRIEND

Gisele Bündchen
SUPERMODEL

Derek Blasberg
WRITER

Brad Kroenig
MUSE / ADOPTED SON

Mary-Kate & Ashley Olsen
DESIGNERS

Daphne Guinness
GUINNESS HEIRESS

Alexa Chung
MUSE

Cara Delevingne
MODEL

Naomi Campbell
& Kate Moss
SUPERMODELS

Bill Cunningham
PHOTOGRAPHER

New York and London fashion weeks were nonstop as usual! I finally have a moment here in Milan to send you a post from the Fendi party for the launch of the newest Baguette, which happens to be in front of the Duomo. *Mon Dieu*, for once it's not under construction and I can actually get a decent photo! I just passed Donatella and Allegra Versace playing tug-of-war against Alberta Ferretti and Miuccia Prada—the chicest and most bizarre rendition of that game I've ever seen. I know I'm jet-lagged, but is Giovanna Battaglia making pizzas with Anna Dello Russo? Is Jeremy Scott serving McDonald's to Rihanna? Maybe I'm just hungry. After I find Karl, I think I'll head for a big bowl of truffle pasta at Bice.

F
9.16.2015 04
MILANO
A 135

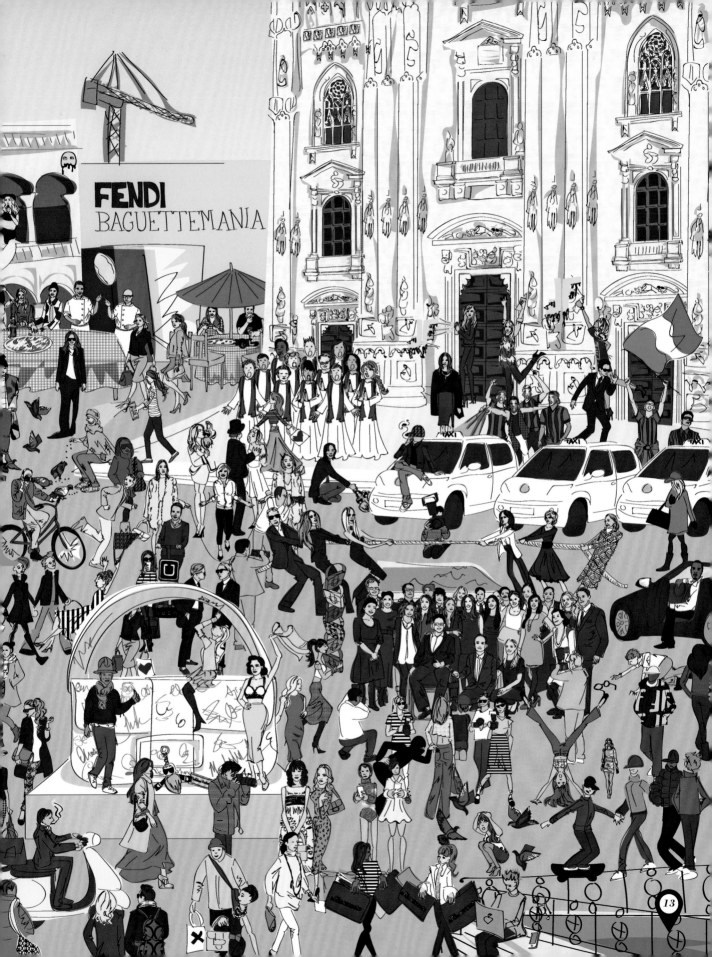

Finally home for a quick snooze in my own bed in Paris as the fashion-month marathon winds down. Karl has *really* outdone himself with the Atlantis underworld theme at this year's Chanel show (massive aquarium = beyond genius). Maybe the invite should have come with a life vest, because things are looking *un peu grave* for Amy Astley and Adam Glassman. Alessandra Ambrosio, Cara Delevingne, and Karen Elson are so brave to walk that inflatable runway. Kendall Jenner is also walking again and stealing the scene from Kris, Kimye, and North, if that's even possible— baby girl has got brows to kill for! Oh, and there are the Emmas, Watson and Stone, looking competitively French, while Blake Lively always manages to look *très* American (in a good way). Karl eventually has to take a bow, so I will see him for sure. Is underwater the new backstage?

10.01.2015 04
PARIS NORD
A 155

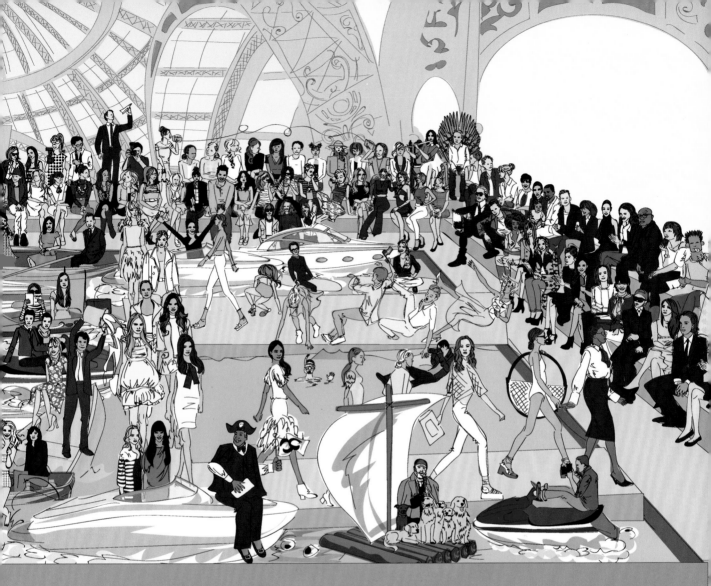
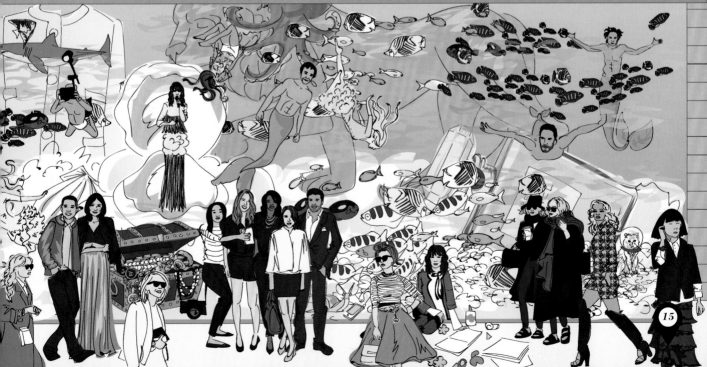

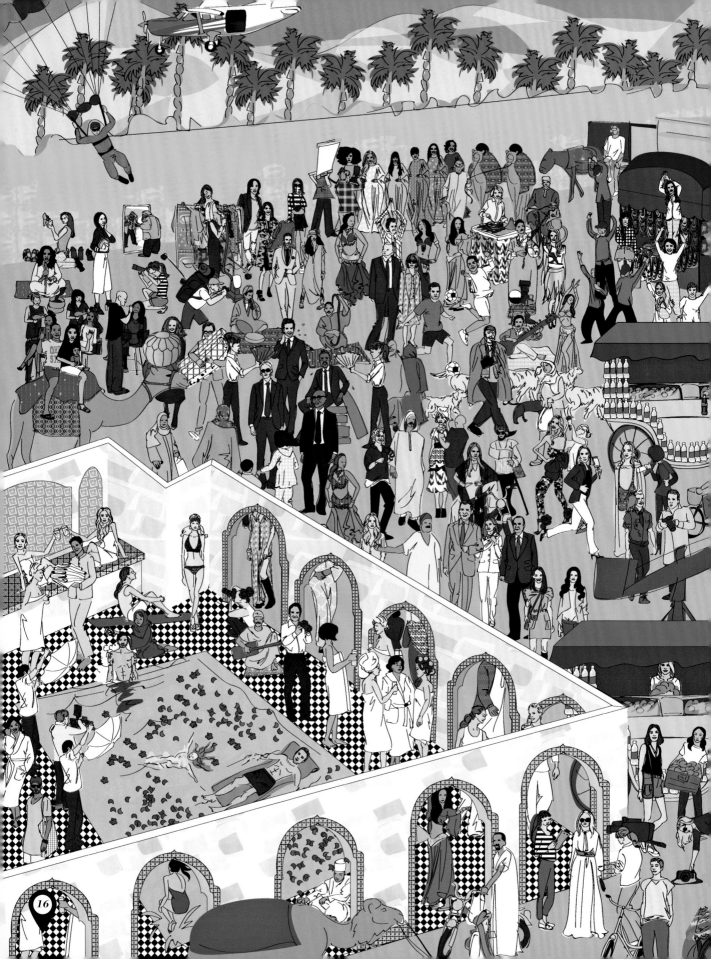

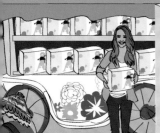

✈ *Bonjour* from Marrakech, where I am helping my fashion godmother Carine Roitfeld on a shoot. Lo and behold, she received a message at her hotel this morning from Karl saying he was also here, directing his latest fragrance commercial. I can't say I'm completely shocked, though, because who isn't here shooting something? Even Lena and her *Girls* have landed, probably filming the Brooklyn-gone-wild version of *Sex and the City 2*. American *Vogue*, French *Vogue*, *W* magazine, *Vanity Fair*, *Lucky* . . . How did they all end up here at the same time!? Well, *peu importe*—works perfectly for me so I can meet my old *Harper's* buddy Eva Chen for dinner at La Mamounia and do a hammam day with Mary-Kate and Ashley. I have a feeling if I hang with this crowd I'll bump into Karl soon enough

10.15.2015

17

Have you been to Karl's pop-up shop in Hong Kong yet? Run, don't walk! MINI-Karls are flying off the shelves. It is complete and utter mayhem, and if I don't keep this short, someone will snatch up all the new Tokidoki dolls before I can get my hands on one. I love that everyone here wears so much black like New Yorkers, but it makes Karl blend in. Just when I thought I'd found him, I got distracted by the last Mua Mua Karl clutch and had to beat Mila Kunis to it. Then I picked up some Shupette cleansing oil for my cat, Coco, and nearly knocked Jenna Lyons's glasses off her face, but only *after* jumping out of Brad Goreski and Rashida Jones's way. Am I the only one who sees Thakoon and Lily Aldridge raiding the cash register? Well, Tavi is no "rookie" to this city, so I'm off to get her tips on finding Karl.

01 NOV 2015
IMMIGRATION

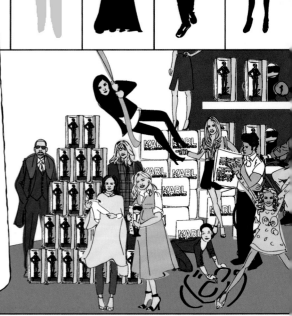

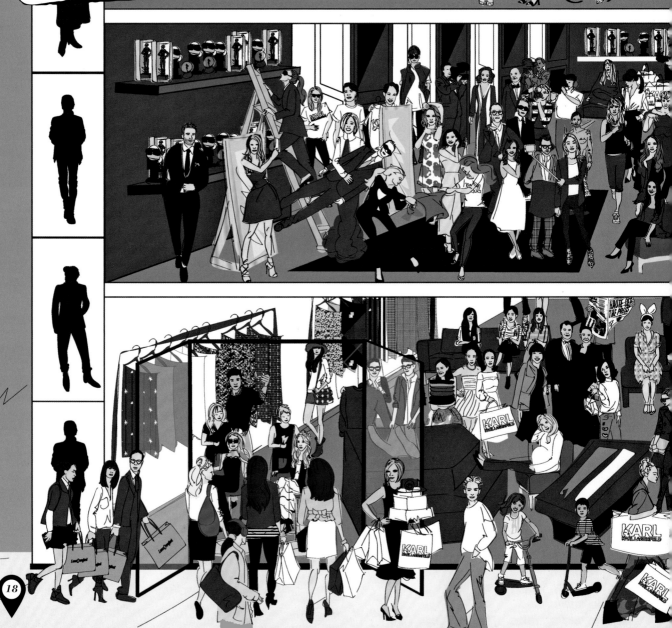

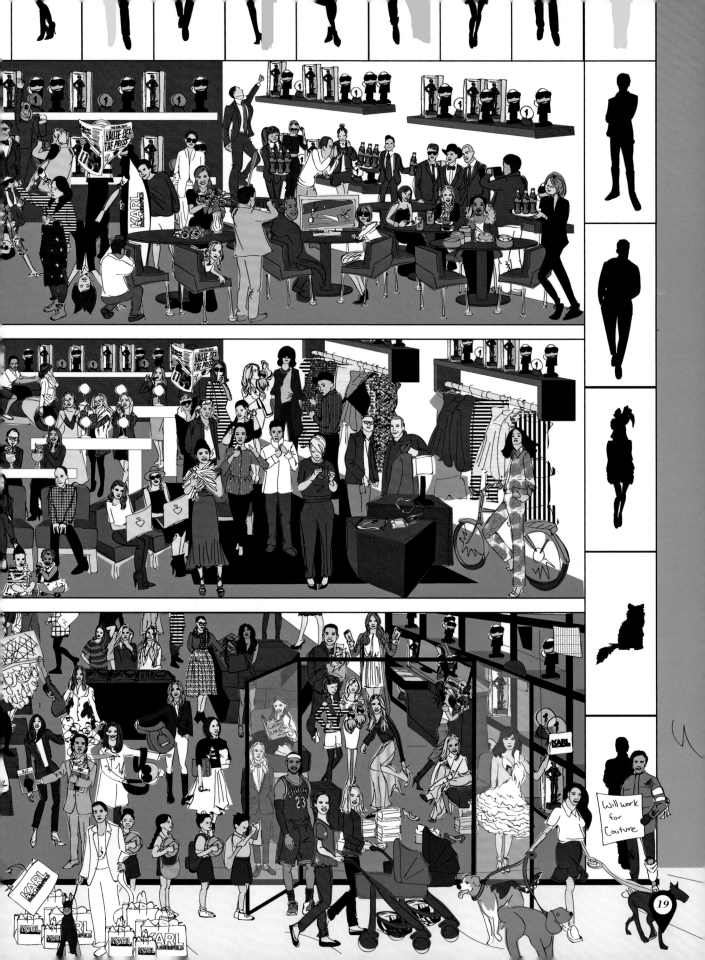

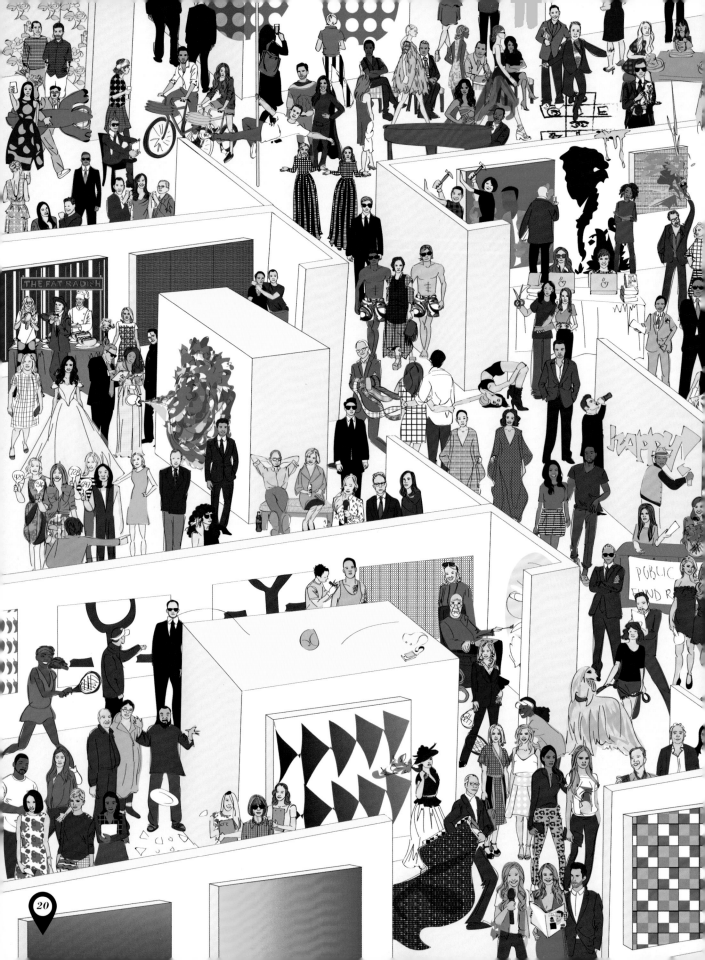

✈ I've heard Karl isn't much of an art guy since his books take up so much space, but I have a feeling that's all about to change, because Simon Doonan and Jonathan Adler told me he would be here at Art Basel Miami to buy and exhibit some of his own work for the first time. My strategy is to meet up with Leo, a dear friend since even before *Titanic*; do a full loop of the space with necessary stops to see two of my fave artists, Jeff Koons and Tracey Emin; and then chat with Chuck Close about that portrait he made of my mother. Speaking of mothers, Beyoncé just zipped by with Blue Ivy in tow, wearing the most darling *petite* Chanel flats! Her fashion sense is beginning to rival Suri's! I can't even . . .

F: ✈
12.03.15 74
MIAMI
A 135

Tulum for Christmas has become a ritual for me—and apparently for the rest of the industry as well. I can hardly get down the beach without bumping into someone I know—and we all seem to be working from our phones! I have already run into Kristen Stewart and Neil Patrick Harris, and Chrissy Teigen literally ran into me. Was *Vanity Fair*'s Michael Carl wearing a costume and chasing someone? Word is that even Monsieur Lagerfeld came out to join the party this year, so tag me if you spot him. Looking forward to a big dinner with Gwynnie, Drew, and Cameron at Hartwood after climbing the ruins. PS: How cute is Rachel Zoe with little Sky Sky and Kaius?

DISTRITO FEDERAL
24 DIC 2015
MEXICO

COQUI-COQUI

LA CAFETE

COQUI-COQUI

FRAGANCES CANDLES PAREOS HATS SANDALS
PERFUMERIA BEACH BOUTIQUE
ESSENTIAL OILS HAMMOCKS

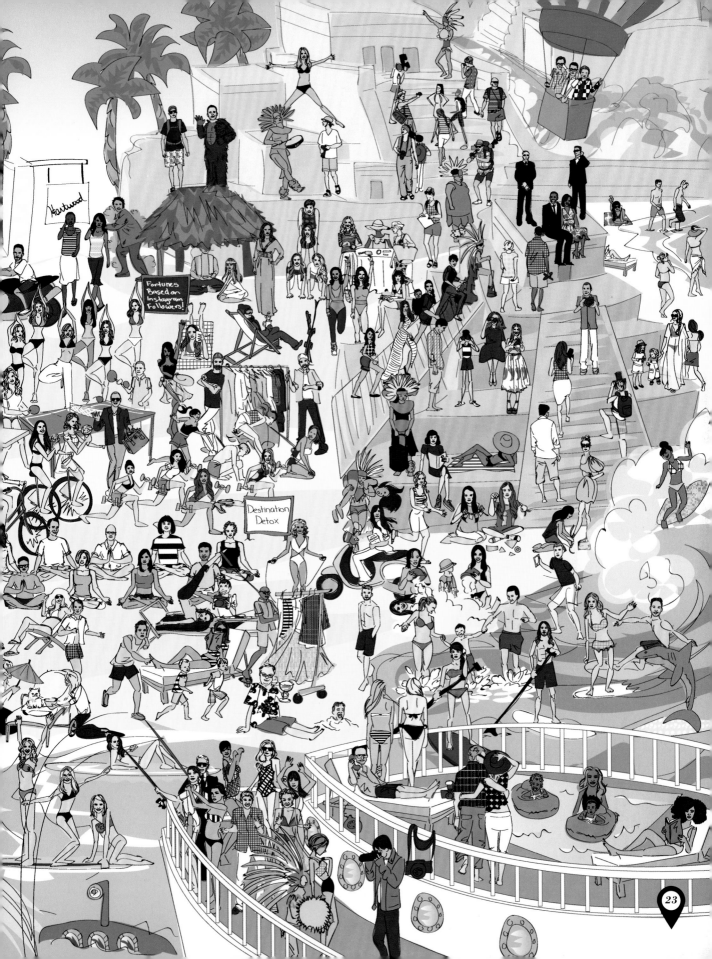

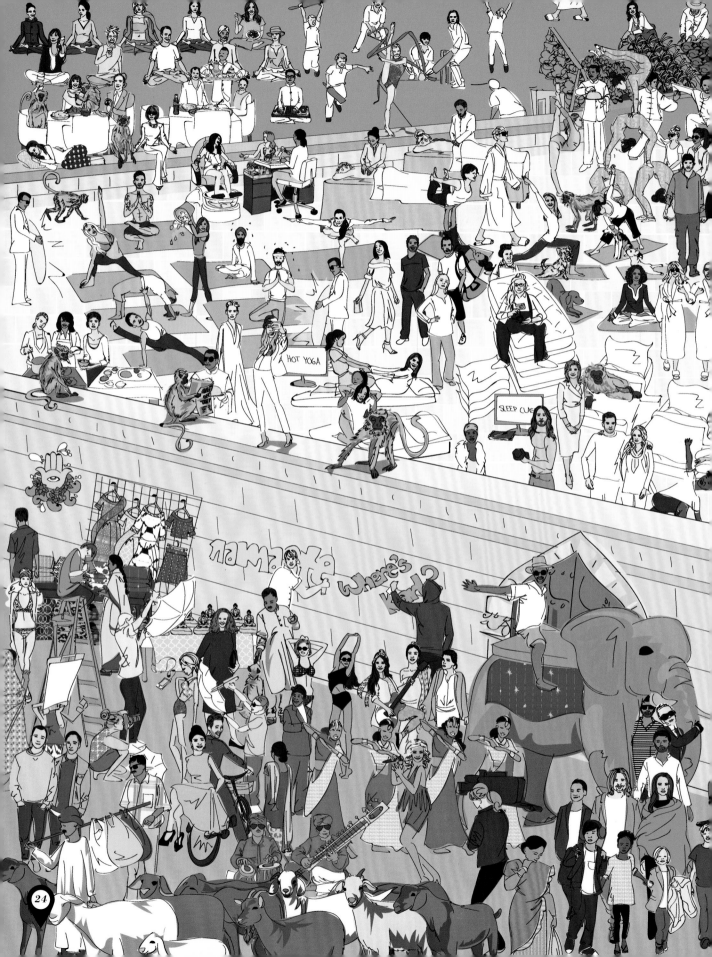

HOT YOGA

SLEEP CLASS

namaste where's Wald?

24

There is no better way to start the new year than by cleansing my soul in solitude and rejuvenation at the Aman hotel's yoga and meditation retreat in India. Sure, it's hosted by Oprah and Christy Turlington and everyone I know is here, but let's ignore that little fact and focus on the Zen. I am here to breathe in, breathe out, and be mindful of the fact that Karl might be in town. Is he hopping on the meditation bandwagon with Liv Tyler and Courtney Love, or is he more into yoga with Gisele Bündchen and Kate Moss? Maybe he is just here gathering inspiration for his next collection? Let me know what you hear. Namaste.

INDIA IMMIGRATION
CHENNAI AIRPORT
01 JAN 2016

YOGA

✈ St. Moritz has been my favorite place to ski since back in my boarding school days. You know, I can't actually think of a time I made it to the slopes, but I am spectacular at *après-ski*. I suppose a few *sportiv* souls like Jennifer Lawrence and Pippa Middleton made it out there. Stella McCartney was testing gear for her Adidas line, too—I hope I can get some swag to help feed my SoulCycle addiction. I am most interested in swinging by the polo tourney on the frozen lake to catch a glimpse of Nacho Figueras and enjoying fondue and champers later with Valentino and Giancarlo. Do you think Karl is a skier or a snowboarder?

:CH:
02.02.16 58
ST. MORITZ
A 135

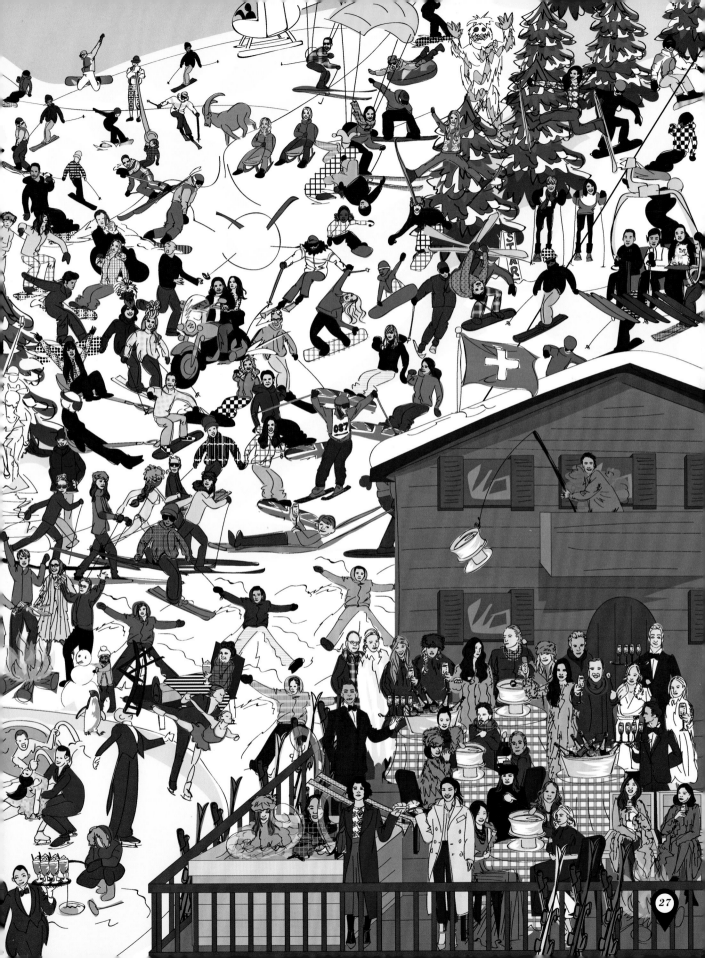

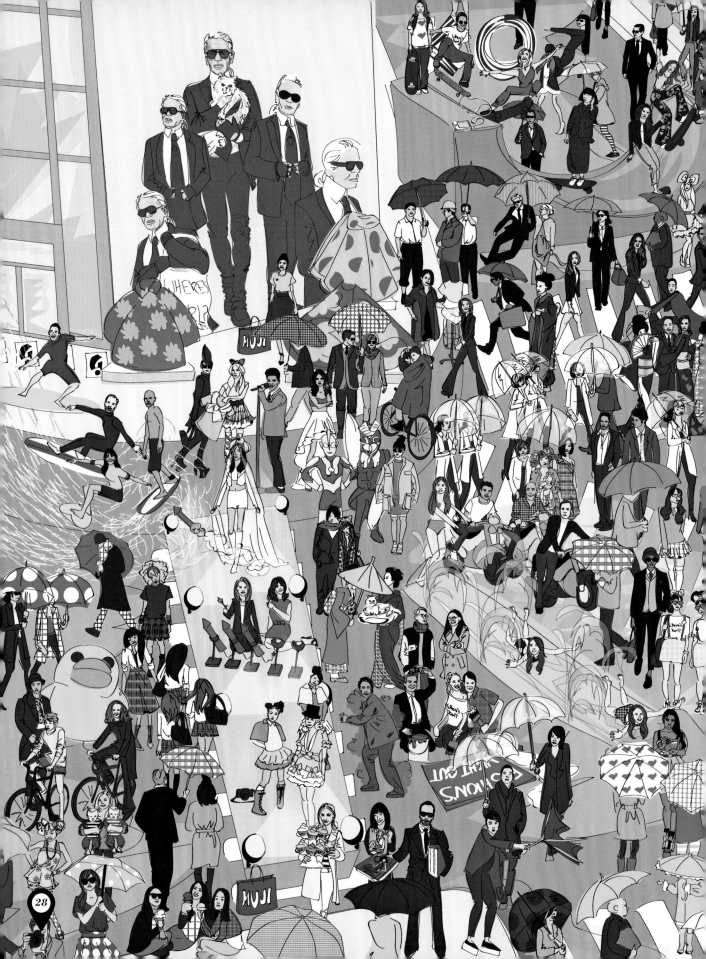

✈ I'll have to keep this short—it's raining here for Tokyo's Fashion's Night Out and I can't suffer another iPad mishap. The weather has prevented my hair from looking even half-good, but it hasn't stopped the fun here in Shibuya Crossing. That savvy Emily Weiss was handing out Glossier umbrellas, which I should have grabbed. Derek Blasberg and Karlie Kloss are supposedly dressed up as geishas, and I even spotted Miranda Kerr sloshing around with Hello Kitty. Have you heard the news that she is now considered a real person, not a cat? I hope Choupette knows. I'm sure Karl is dry—probably hanging somewhere with Alexa Chung and Poppy Delevingne. I officially want to come back as an *haute* Harajuku girl in my next life. I'm off to 109 to check out the latest trends.

✈ I'm writing to you from the Chateau Marmont at the mayhem-as-usual Academy Awards after-party. (Can we still call it the after-party if the sun has already come up and we're onto the next day? LA really is nonstop!) I am not sure how the Coppolas can concentrate on their meeting when Ellen is making s'mores and Nicole Richie is doing poolside yoga. I need to focus and find Karl, but I got distracted looking for

Matthew McConaughey's Oscar with Lupita. Mindy Kaling just texted me about laying out later—cannot wait to take off these heels and cruise for Karl poolside with a cocktail in hand!

F
02.22.16 47
LOS ANGELES
A 135

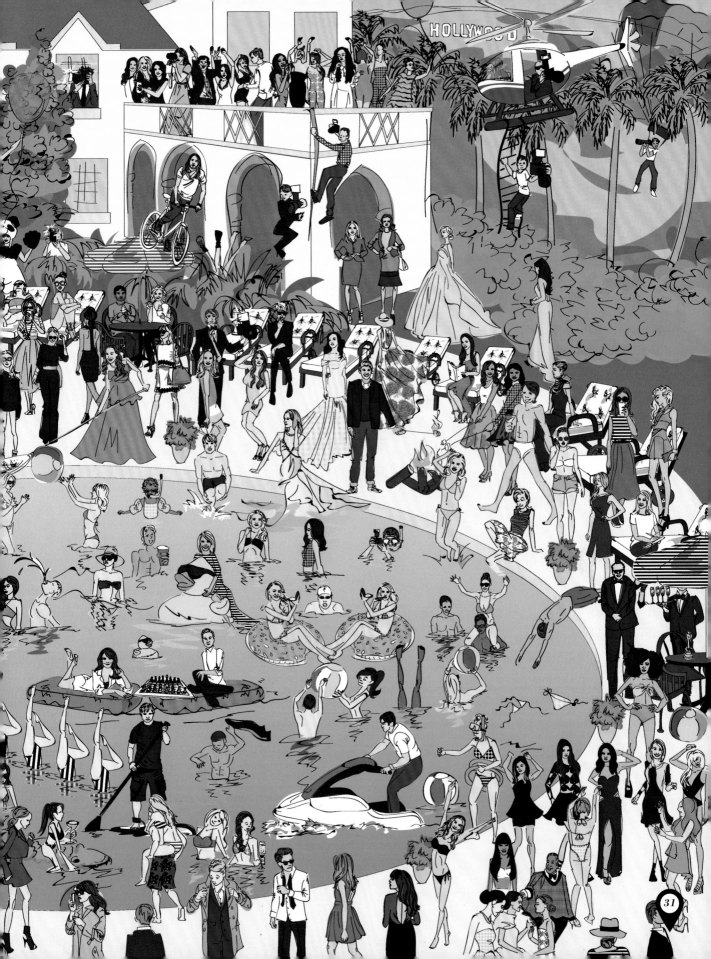

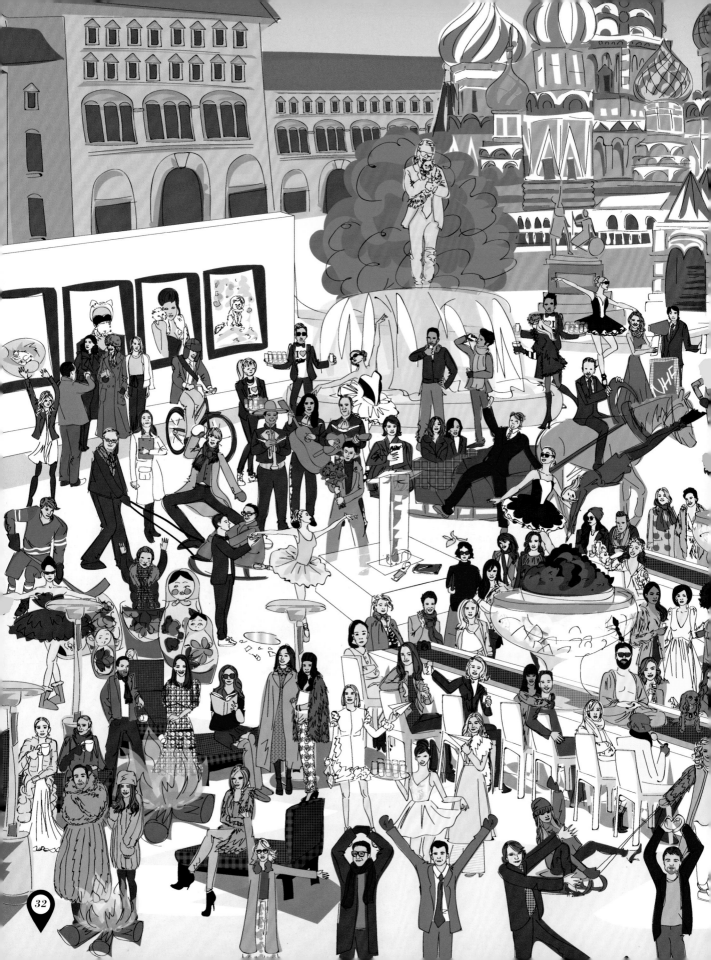

Just a quick note from the Buro 24/7 luncheon in Moscow that Miroslava Duma is hosting to celebrate Karl's most recent collection of photographs of Choupette. I'm not sure if it's all the vodka and caviar or just the freezing temperatures, but everyone has gone a little nutty—especially the New Yorkers. The Fat Jew is holding court with his dog, Toast, and my fellow bloggers Leandra Medine, Susie Bubble, and Bryanboy were last seen in a giant snowball fight. I'd better stick with Anna Wintour and her daughter, Bee, to avoid taking one in the face. Did Lynn Yaeger just walk by mumbling something about hot Russian dolls? OMG, Becks just called to tell me a snowman styling contest has officially begun. Be right there—just have to bust out my Balenciaga cape!

РОССИЯ
КПП
03.20.16 >1
301 ШЕРЕМЕТЬЕВО 301

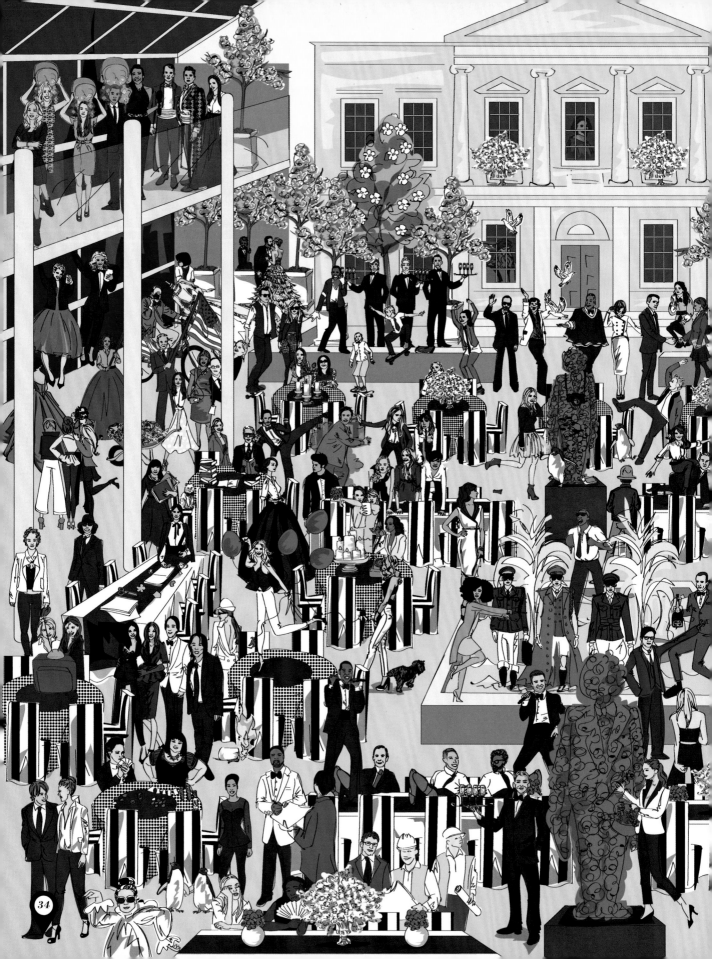

Hello from the Fashion Oscars—the Met Gala in the Big Apple! Marc Jacobs is such a darling for bringing me as his date, but he ditched me to get a tattoo! (See my Insta pic for the regram.) This year is all about the history of suits and shirttails in fashion—so Karl, *non*?—but there is nothing buttoned up about this crowd. Grace Coddington brought her cats and André brought doves. Kerry Washington is "handling" TSwift's selfie #scandal, but it doesn't matter because Bill Cunningham is getting it all on camera anyway. Karl couldn't be swinging from the rafters with Kelly Osbourne and Rita Ora . . . could he?

05.03.16 04
NEW YORK
A 135

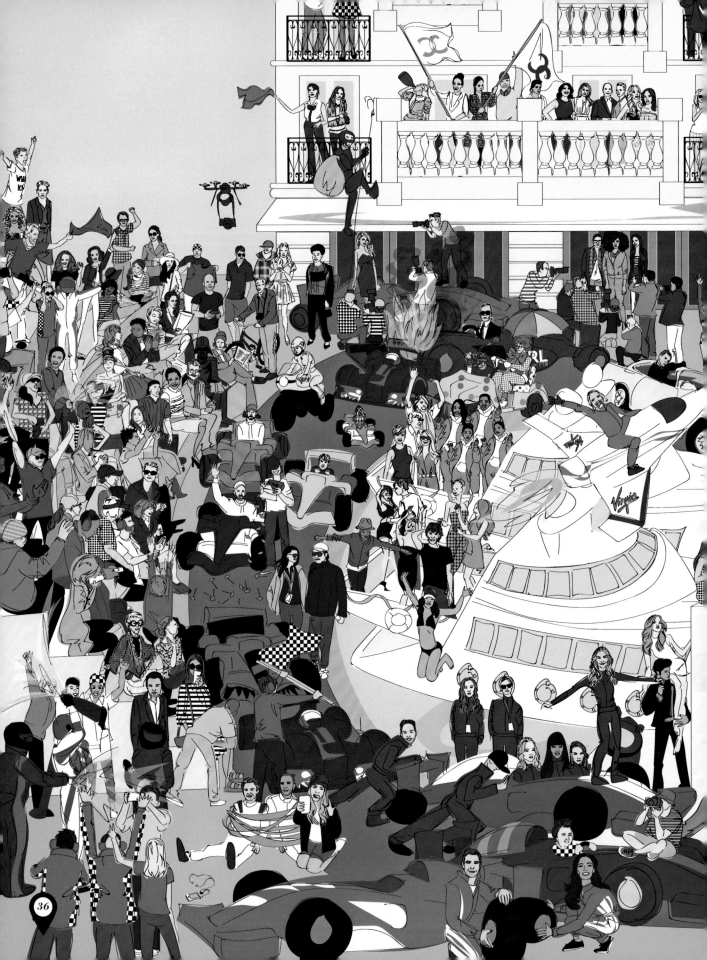

✈ I can barely hear myself type with all the commotion and excitement of the Formula 1 Grand Prix here in Monte Carlo. Aren't racecar drivers *très* sexy? Wait, did I just see Suzy Menkes zip by? Oh, there goes Naomi Campbell! Is George Clooney changing Amal's tire? I kind of hope she wins. Chanel is sponsoring a few cars this year, so Karl could be anywhere. I need to focus on finding him before Djokovic and I meet up with Serena and Federer for our doubles game after the race. If I don't pay attention, I may end up as fashion roadkill—these drivers are all over the place!

PRINCIPAUTÉ DE MONACO
21 MAY 2016

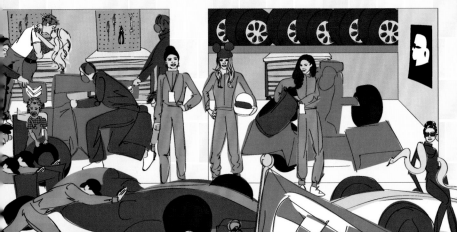

KARL
KARL LAGERFELD

KARL
KARL LA...

Writing you from my first visit to Dubai, which is out-of-this-world amazing. Karl must have loved it so much when he staged his Chanel show that he came back to shoot an ad campaign. Yours truly received an invitation to play an extra on set alongside the who's who of Dubai. It helps to have a casting agent for a friend, *non*? Some of his past stars are here too: Nicole Kidman, Diane Kruger, Tilda Swinton, and Keira Knightley, who's been a close friend since I assisted on her 2012 *Vogue* cover shoot. I think I see Karl playing around in the dunes, or maybe it's just the heat causing a mirage . . . stay tuned . . .

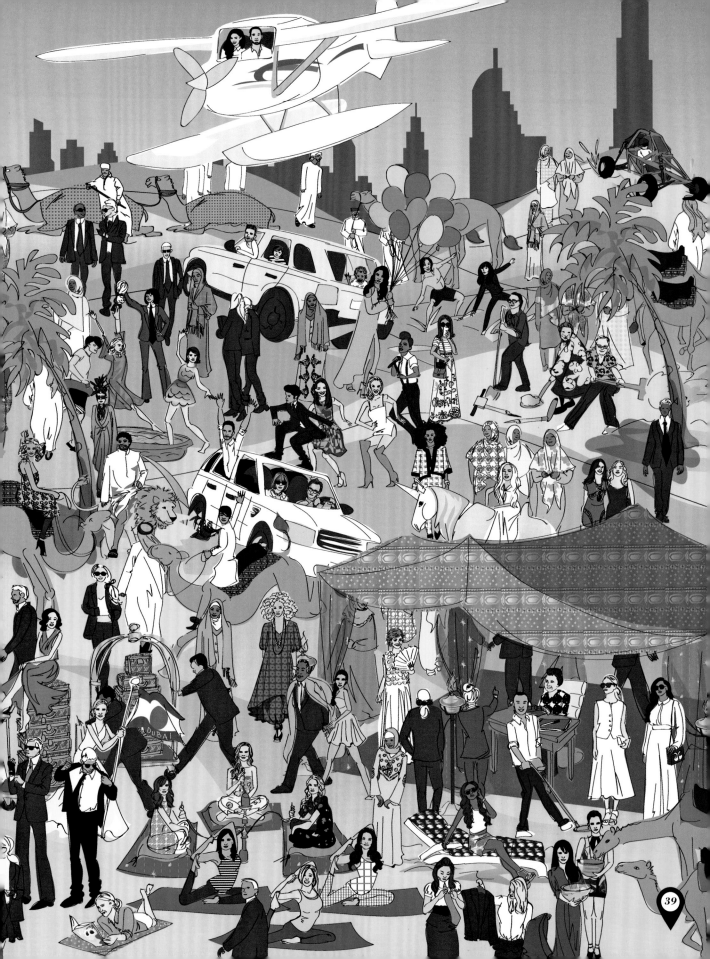

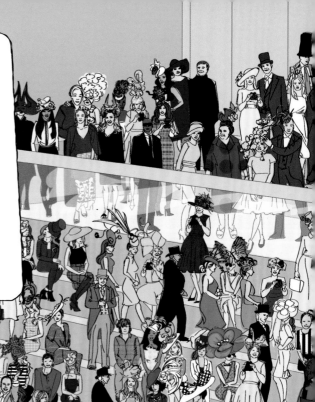

It's Royal Ascot time! Here I am in London at the most glamorous horse race in all of Europe, but who can take their eyes off the parade of fascinators? Now that Karl and Queen Elizabeth are friends, he has come as her personal guest, but he wasn't in his seat the last I looked. I'm dying for Kate's Issa dress! Jagger is moving like, well, Jagger on top of Elton John's piano, and Madonna is celebrating her status as an honorary Brit.

I need to go place my bet on Oknow SheDeednt. Wait. A. Second. Karl is literally standing two Philip Treacy hats away from me . . .

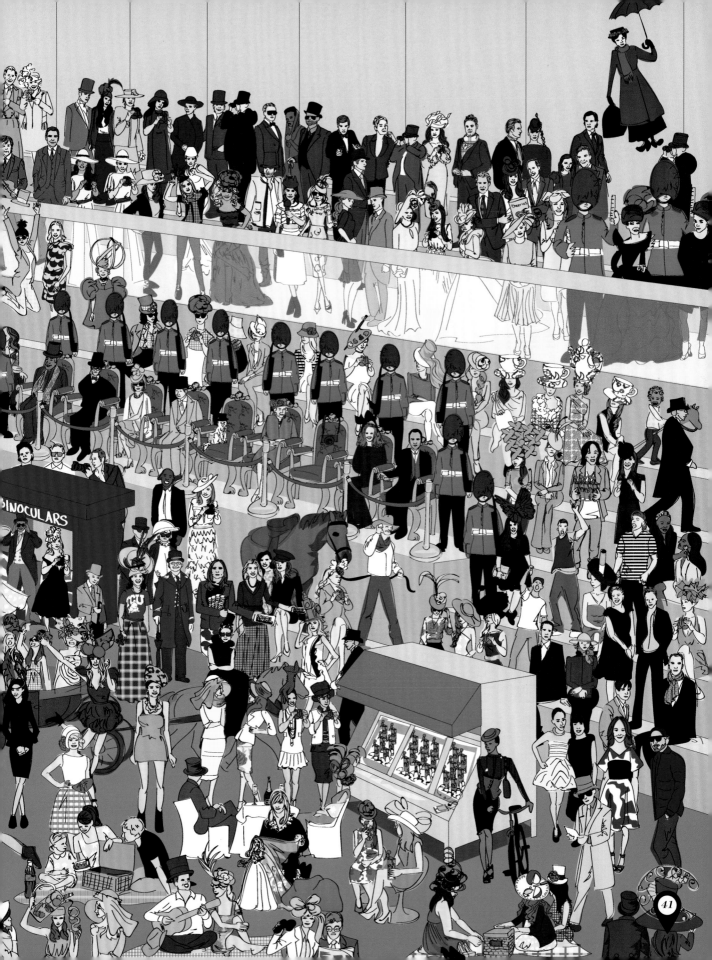

CHECKLISTS

Bien sûr, if I were to tell you about *everyone* I ran into, we would have an epic encyclopedia of fashion and pop culture. I want to make sure you don't miss these fabulous and fun favorites, but I simply don't have the time to list them all—not when I'm prepping for my next adventure! Always be sure to keep an eye out—you never know who you'll bump into when you're looking for Karl . . .

✈ PARIS

◇ Snail listening to Karl's iPod

◇ Rachel Bilson enjoying ice cream

◇ Claudia Schiffer jumping off a boat

◇ Choupette scuba diving

◇ Angelica Cheung, Emmanuelle Alt, and Franca Sozzani playing poker

◇ Bruce Weber keeping afloat with his dogs

◇ Taylor Tomasi Hill delivering flowers

◇ Inès de La Fressange writing her next book

◇ Baz Luhrmann enjoying a perfect seat

◇ Angelina Jolie and Brad Pitt with their brood

◇ Nina García fighting a pirate

◇ Peter and Harry Brant riding a Jet Ski

◇ Nicole Kidman knitting a sweater

◇ Lindsay Lohan and Janelle Monáe cheering on Karl

◇ Lily Collins playing the flute

✈ MILAN

◇ Homeless man in Gucci shoes

◇ Space invader graffiti

◇ Michel Gaubert DJing the party

◇ Six Karlito keychains, one with the golden ticket

◇ Mickey Boardman singing in the choir

◇ Pharrell decorating a giant Fendi Baguette

◇ Dita Von Teese performing

◇ Garance Doré taking pics

◇ Olivia Palermo taking a break

◇ Stephan Gan hiding a stash of keychains

◇ Ariel Foxman trying out an Uber Segway

◇ Sneaky pickpocket

◇ Sean "Diddy" Combs stepping out of a black car

◇ Roberto Cavalli planning a party

◇ Dolce and Gabbana tossing pizzas

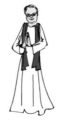

✈ MARRAKESH

◇ Jourdan Dunn and Pat Cleveland posing for *CR Fashion Book*

◇ Tonne Goodman running with her lint brush

◇ Annie Leibovitz shooting Karl's muses for *Vanity Fair*

◇ Mark Seliger shooting Ryan Gosling floating in the pool

◇ Johnny Depp sipping tea with some "friends"

◇ King Felipe, Queen Letizia, and King Juan Carlos taking a local tour

◇ Martha Stewart cooking couscous in the Square

◇ Scott Schuman snapping a pic of Nick Wooster

◇ Jessica Alba handing out Honest diapers

◇ Tory Burch selling oranges

◇ Monkey trying on clothes

◇ Cristiano Ronaldo playing soccer with Joshua Jackson

◇ Kevin Hart and Bradley Cooper trying to stay cool

◇ Kelly Rowland snake charming

◇ Robin Roberts on a camel ride

✈ HONG KONG

◇ Selby Drummond taking inventory

◇ Diane von Fürstenberg filming a new episode

◇ Björk stickering the walls

◇ Suki Waterhouse jogging

◇ Leigh Lezark swinging from a rope

◇ Melvin Chua and Zhang Ziyi trying on collars

◇ Amanda Brooks ready to go horseback riding

◇ Jessica Joffe voguing in the mirror

◇ Carey Mulligan trying on clothes

◇ Linda Fargo swiping a Karl mannequin

◇ Glenda Bailey arranging flowers

◇ Snoop Dogg eating dim sum

◇ LeBron James leading a kid's camp on a shopping trip

◇ Gigi Hadid photo bombing with a selfie stick

◇ Imran Amed passing out *Business of Fashion*

✈ TULUM

◇ Julia Restoin Roitfeld burying her mother in the sand

◇ Nicola Formichetti making a dress for Lady Gaga

◇ Kate Bosworth riding the waves

◇ Iris Apfel cooking

◇ Dree Hemingway bird-watching

◇ Edward Enninful prepping for a shoot

◇ Caroline de Maigret riding across the sand

◇ Donna Karan and Aliza Licht jazzercising

◇ Miley Cyrus flying a kite

◇ Hamish Bowles in a hot-air balloon

◇ Ellen DeGeneres and Portia de Rossi having fun

◇ Giorgio Armani getting a tan

◇ Michael Kors juggling

◇ Francesca Bonato and Nicolas Malleville welcoming guests

◇ Chris Harrison and Lara Spencer crowning Miss Tulum

✈ MIAMI

◇ Alexander Wang cutting up a T-shirt

◇ Two robbers taking off with goods

◇ Samantha Yanks and Aby Rosen admiring art

◇ Rachel Feinstein and Cindy Sherman posing as twins

◇ Yvonne Force Villareal raising money for public art

◇ Gayle King giving away presents

◇ Larry Gagosian and Annabelle Selldorf building a log cabin

◇ Tyra Banks, J. Alexander, Nigel Barker, and Jay Manuel casting

◇ Lady Bunny riding a sculpture while Brian Bolke snaps a pic

◇ Emmy Rossum tap dancing

◇ Carson Daly interviewing NeNe Leakes

◇ Laura Brown and Kiernan Shipka chatting

◇ Adam Levine and Behati Prinsloo reading *People* magazine

◇ Scott Disick and Kourtney Kardashian getting ready for a costume party

◇ Channing Tatum pole dancing

✈ INDIA

◇ Jason Wu dressing local girls

◇ Deepak Chopra DJing his meditation class

◇ Julia Roberts eating a bowl of pasta

◇ Tracy Anderson chair dancing

◇ Camilla Nickerson on the phone

◇ Rachel Roy carrying goods from the market

◇ Monkey reading *Karl Daily*

◇ Arianna Huffington and Cindi Leive teaching the art of sleeping

◇ Margherita Missoni jamming

◇ Jennifer Aniston doing yoga with her dog

◇ Wes Anderson teaching campers cricket

◇ Linda Evangelista gardening with the local chef

◇ Jared Leto lifting weights

◇ Harvey Weinstein with electronic devices

◇ A local artist creating a masterpiece out of lentils

✈ ST. MORITZ

◇ Ralph Lauren with an apple pie
◇ Princess Beatrice and Princess Eugenie sharing skis
◇ Phillip Lim, Wen Zhou, and Richard Chai on the chair lift
◇ Bono and the Edge with the Jamaican bobsled team
◇ Madeline and her dog headed to Badrutt's Palace
◇ Sarah Andelman snowboarding in sneakers
◇ Graydon Carter taking a ski lesson from Michael Roberts
◇ Lily Allen shovel racing
◇ Man in Chanel lederhosen
◇ Caroline Issa and Yasmin Sewell toasting croissant s'mores
◇ The Abominable Snowman
◇ Justin O'Shea and Paula Reed dropping in by parachute
◇ Christopher Kane and Mary Katrantzou representing the UK on snowboards
◇ Mario Testino and Tatiana Santo Domingo giving a toast
◇ Homeless party crasher

✈ LOS ANGELES

◇ Giuliana and Bill Rancic filming for E!
◇ Jacqui Getty cleaning the pool
◇ Six Oscar statues
◇ Kate Lanphear scoping out the scene
◇ Woody Allen playing mahjong with Scarlett Johansson and Rachel McAdams
◇ China Chow photographing Michael Chow for Instagram
◇ Sofía Vergara dressed as a mermaid
◇ Kristin Cavallari roller-skating
◇ Lisa and Laura Love handing out roses
◇ Amy Poehler and Aziz Ansari on an ice cream break
◇ Thirteen paparazzi
◇ Lauren Santo Domingo dancing poolside
◇ Lauren Conrad taking notes
◇ Chelsea Handler going for a ride
◇ Kate Hudson in the pool

✈ TOKYO

◇ Phoebe Philo, Riccardo Tisci, and Khloé Kardashian posing as the Beatles
◇ Julie Gilhart and Kelly Slater riding surfboards
◇ Jeffrey Kalinsky pushing his motorcycle
◇ Nicki Minaj signing autographs
◇ Four Muji bags and three Where's Karl? T-shirts
◇ Sarah Jessica Parker and Matthew Broderick painting signs
◇ Kristina O'Neill, Elisa Lipsky-Karasz, Ian Mohr, and Meenal Mistry riding in the back of a truck
◇ Tom Ford passing out *Vogue Japan* magazines
◇ Natalie Massenet lighting firecrackers with Alison Loehnis
◇ Yohji Yamamoto helping his four minis cross the street
◇ Rei Kawakubo on a skateboard
◇ Bruno Mars and Selena Gomez performing in the rain
◇ Emily Schuman stacking cupcakes
◇ One Direction members running from a mob of girls
◇ Chiara Ferragni puddle jumping

✈ MOSCOW

◇ Shakira dancing in a grass skirt
◇ Natalia Vodianova making an announcement with a bullhorn
◇ Vanessa and Samantha Traina hula-hooping
◇ Ulyana Sergeenko dancing to the Pussy Riot performance
◇ Zac Posen and Zoe Saldana making snow angels
◇ Tabitha Simmons on the hunt for her shoes
◇ Misty Copeland teaching Prabal Gurung pirouettes
◇ Jean Paul Gaultier relaxing on a lounger
◇ Elena Perminova and Nasiba Adilova flying paper planes
◇ Alber Elbaz taking a tea break with Kanye
◇ Stefano Tonchi and Olga Kurylenko doing the tango
◇ Jane Birkin and Lou Doillon playing guitar
◇ Salma Hayek and François-Henri Pinault in a mariachi band
◇ Black swan in Uggs
◇ Giambattista Valli and Jessica Biel staying warm

✈ NEW YORK

- ◇ Zoë Kravitz and Georgia May Jagger forming a human pyramid
- ◇ Hedi Slimane receiving guests
- ◇ Anderson Cooper, Jimmy Fallon, and Andy Cohen filming
- ◇ Barack Obama disguised as Michael Jackson
- ◇ Solange Knowles doing the running man
- ◇ Diana Vreeland statue having a chat with the curator
- ◇ Carol Lim and Humberto Leon plucking rose petals
- ◇ Rosie Assoulin posing for Tommy Ton
- ◇ Tina Fey hanging with Alec Baldwin
- ◇ Justin Timberlake and Jay-Z dancing
- ◇ Conchita Wurst taking a selfie
- ◇ The ghosts of Leonardo da Vinci and Caravaggio
- ◇ Gwen Stefani and Gavin Rossdale skateboarding with their kids
- ◇ La La Anthony and Alicia Keys posing
- ◇ Julian Schnabel sleepwalking

✈ DUBAI

- ◇ Katy Perry singing karaoke
- ◇ Vanessa Paradis trying to stay cool
- ◇ Freida Pinto helping herself
- ◇ Chanel Iman with a few too many balloons
- ◇ Alex de Betak running the show
- ◇ Kylie Minogue teaching dance moves to Sofia Sanchez Barrenechea
- ◇ Amber Venz on a camel
- ◇ Lost unicorn
- ◇ Joe Zee hunting treasure
- ◇ Esther Quek hitting golf balls
- ◇ Ramzi Tabiat landing a plane
- ◇ Haya and Sama Abu Khadra sharing hair secrets with the Olsen twins
- ◇ Hannah Bronfman holding a garment bag
- ◇ Brad Kroenig having fun with his son
- ◇ Broken metal detector

✈ MONTE CARLO

- ◇ Nico Rosberg and Lewis Hamilton in a tie
- ◇ Sir Richard Branson ready for take-off
- ◇ Will Smith, Jada Pinkett Smith, and family getting jiggy
- ◇ Iron Man saving the day
- ◇ Princess Caroline of Hanover waving her scarf
- ◇ Karolína Kurková stealing a car
- ◇ Justin Bieber chasing his car
- ◇ George Lucas and Darth Vader counting money
- ◇ Trail of nails ready for sabotage
- ◇ Ron Howard racing a drone
- ◇ Daft Punk spinning vinyls
- ◇ Perez Hilton ready to blog
- ◇ Barbie speeding by
- ◇ Prince Carl Philip counting his chips
- ◇ Nicole Scherzinger driving a simulator

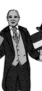

✈ LONDON

- ◇ Kermit the Frog strolling with Miss Piggy
- ◇ Paul McCartney jamming with George Clooney
- ◇ Grace Jones on the hunt for James Bond
- ◇ Lady Amanda and Tallulah Harlech caught by the guards
- ◇ Tom Brady throwing a pass to his lady
- ◇ Alexandra Shulman and Sarah Rutson handing out pamphlets
- ◇ Mary Poppins trying not to stay grounded
- ◇ Sumo wrestler riding bareback
- ◇ Sir Philip Green shopping for his topper
- ◇ Duke and Duchess of Cambridge giving a cheerio to Prince Harry
- ◇ Prince Charles and Camilla Parker Bowles with a spot of tea
- ◇ Gangsta Granny pickpocketing David Walliams
- ◇ Sarah Burton prepping the ultimate wedding
- ◇ Dakota Fanning rocking out
- ◇ Daphne Guinness riding sidesaddle

ACKNOWLEDGMENTS

First of all a big thanks to Michelle Baron, our illustrator extraordinaire, who turned our crazy ideas, countless e-mails, calls, meetings, and very long list of wishes into this book.

We would like to thank our families—Steve, Lilly, Greg, John, Amy, Collins, Chester, and Ernest Jr.—for their continued support and generous feedback. We also have to say a big thanks to our husbands—Javier and Thomas—for putting up with our Karl marathon and transatlantic meetings at odd hours. A very special *merci* to our editor Amanda Englander and agent Alyssa Reuben for making this all a reality and for their guidance through this process, endless patience, and not killing us when we used too many exclamation points. Thank you to Katelyn Dougherty at Paradigm for always making sure we have what we need. We are lucky to have our "old-school" globe-trotting friends Amanda Alvarez, Amanda Assad Mounser, David Lipke, Eugenia Gonzalez, George Sotelo, Mary Song, Mia Young, and Sergio Urias, who were never short on funny ideas and tips. Special thanks to Thakoon Panichgul and Maria Borromeo. We must also acknowledge our additional eyes— Amy Plum and Collins I. Aki—and our additional ears—Maggie Kim, Cassi Bryn Michalik, and Julie Tran Lê—for always being available to read Fleur's blog at a moment's notice and listening to never-ending talk of Karl and fashion. And finally to our Noomi—who will one day find herself in the pages of this book and want to know all about *l'esprit du temps* from her mother and godmother.

ABOUT THE AUTHORS

AJIRI A. AKI moved to New York City from Austin, Texas, and began her career in fashion working as associate men's fashion editor at *Daily News Record* (now *Women's Wear Daily*) and then as senior accessories and celebrity sittings editor at the now-defunct *Suede* magazine. She went on to get her master's degree in decorative arts from the Bard Graduate Center and worked with the Costume Institute of the Metropolitan Museum of Art and the Museum of the City of New York. Ajiri is now a fashion video producer and has worked with companies such as Neiman Marcus, Macy's, Farfetch, Marchesa, and Rachel Roy. She lives in Paris with her husband and daughter.

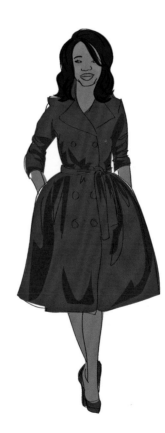

STACEY CALDWELL, the vice president of global wholesale for American fashion designer Thakoon, lives in Brooklyn, New York, with her husband. Originally from El Paso, Texas, Stacey moved to New York in 2003 with a bachelor's degree in fashion promotion and minor in photography from Texas Christian University. Stacey has spent the last twelve years developing the wholesale businesses of the brands Moschino, Basso & Brooke, Sinha-Stanic, Pollini, and Thakoon. Stacey currently sits on the board of Project Paz, a New York–based nonprofit organization benefiting children in Ciudad Juárez, Mexico, which she cofounded in 2010.

Following Fleur

¶ | Home sweet home. What a trip! I'm still dreaming of those Hartwood margaritas and that Russian caviar. Do your feet hurt as much as mine? Thank goodness sneakers and flats are back in style. I'm sure you are dying to read about my meeting with Karl—yes, it happened! But a respectable girl never gives up her goods that easily. You will have to follow me online to read the full interview and keep checking back as FollowingFleur.com begins its transformation into The Fashion Blog To End All Fashion Blogs.

Follow me
www.followingfleur.com
www.whereskarlthebook.com
Instagram: @whereskarl

One more thing: I want to see your photos from the trip, too, so remember to hashtag #whereskarl if you have any clues or—even better—a sighting.

MEET FLEUR

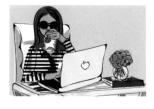

#fleurfollowers
#followingfleur
#worldtour
#confessionsofakarloholic
#whereskarl